# ST AUSTELL

## HISTORY TOUR

WCV 198

First published 2009
This edition published 2014

Amberley Publishing
The Hill, Stroud,
Gloucestershire, GL5 4EP
www.amberley-books.com

Copyright © Valerie Jacob, 2014

The right of Valerie Jacob to be
identified as the Author of this work
has been asserted in accordance with
the Copyrights, Designs and Patents Act
1988.

ISBN  978 1 4456 4178 2 (print)
ISBN  978 1 4456 4188 1 (ebook)

British Library Cataloguing in
Publication Data.
A catalogue record for this book is
available from the British Library.

Typesetting by Amberley Publishing.
Printed in Great Britain.

# INTRODUCTION

St Austell, about 2 miles from the South Coast, developed from a 'poore village with nothing notable but the Paroch Church', according to John Leland, an early traveller in Cornwall between the years 1535 and 1543.

St Austell, Austol or Austle, a Celtic missionary saint, was a younger companion of St Mewan. They settled within a mile of each other, and St Mewan is still the neighbouring parish. In 1602, Richard Carew described Trenans Austel indicating that the valley at Trenance was probably the first place St Austell chose to settle.

At Menacuddle, a little higher up the valley from Trenance, a hollow in the perpendicular rock face became known as St Austell Well, and the baptistry building that still stands there has a permanent spring and stream of water flowing into a granite basin. It is likely that, somewhere in this area, a small cell with an enclosure was built on the southern slopes, the site of the future town. In 1294, a record from the Tywardreath Priory notes 'Ecclesia de Sancto Austolo', indicating a small chantry chapel, which was later replaced by a parish church.

The development of trade and business around the church is the history of many Cornish towns. In 1695, Celia Feinnes called St Austell 'a little market town', and about a hundred years later another historian, Richard Pococke, named it a 'little tinning town'.

By the mid-1800s, W. G. Maton records that the place only has a church to recommend it but that 'there are large blowing houses at the western extremity' indicating growth and prosperity since the discovery of tin and copper deposits.

By 1833, St Austell was defined as a Coinage Town, indicating its importance, and from the time of Oliver Cromwell a market charter had also been granted. This was soon followed by that of two annual fairs for the sale of livestock, coarse woollens and other manufactured goods. F. W. L. Stockdale, in 1824, records that the people of the town were 'industrious and thriving'.

The next development included the transition to the china clay trade in the early nineteenth century, with the whole area around and to the north of the town producing some of the finest clay deposits in the world. The clay industry employed much of the local work force, the economic and social effects on St Austell being of great importance. The town developed and grew in all directions during the nineteenth and twentieth centuries, and fine houses, avenues and buildings were added to the main streets. The villages around St Austell were thriving communities too and the importance of the town was obvious on market days, Saturdays and feast days, when the population from outlying areas congregated in the streets. The shops thrived with trade, staying open until 9–9.30 p.m. on Saturdays. Canon Hammond, the vicar of St Austell in 1897, called it 'the most flourishing town in the county'.

There have been many changes in the town over the decades, with emphasis on large out-of-town stores. We now have pedestrianisation in Fore Street and Vicarage Place, with the former area, Aylmer Square to South Street, has undergone massive redevelopment.

# ST. AUSTELL.

Come here
and you will have something
to Crow about.

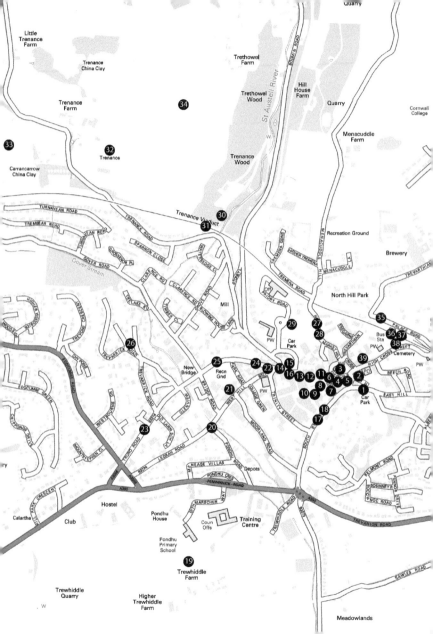

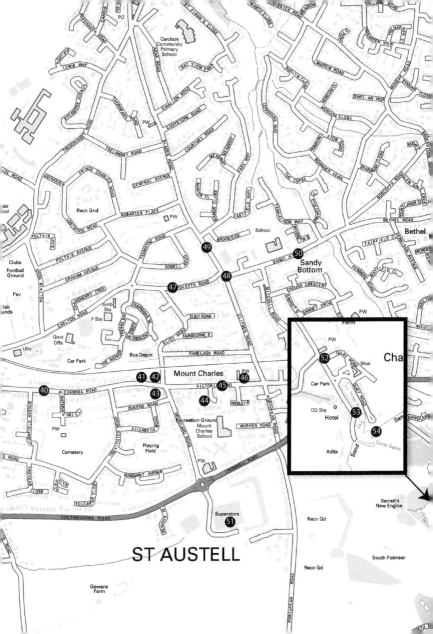

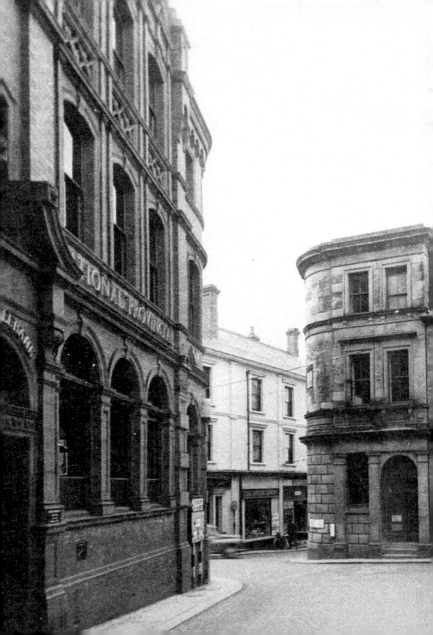

# 1. CORN EXCHANGE

At the lower end of East Hill, on the corner of Hotel Road and Church Street, was the Corn Exchange dated 1859; this fine granite building became the district food office during the Second World War. Demolished in 1960, for modern traffic purposes, it opened up today's view of lower East Hill.

## 2. EAST HILL

A view of the lower end of East Hill approach to the church. In the 1960s, road improvements demolished many of the buildings on the left-hand side coming down the hill. It was once the main thoroughfare out of the town to the coastal ports and beyond into Devon.

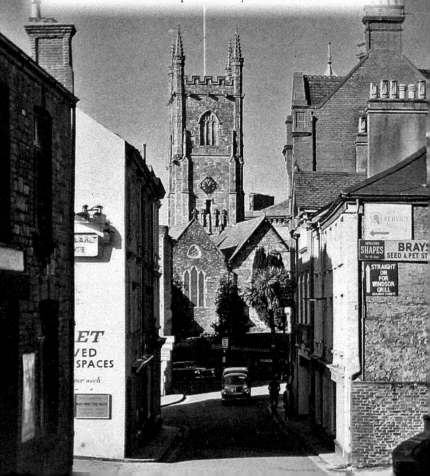

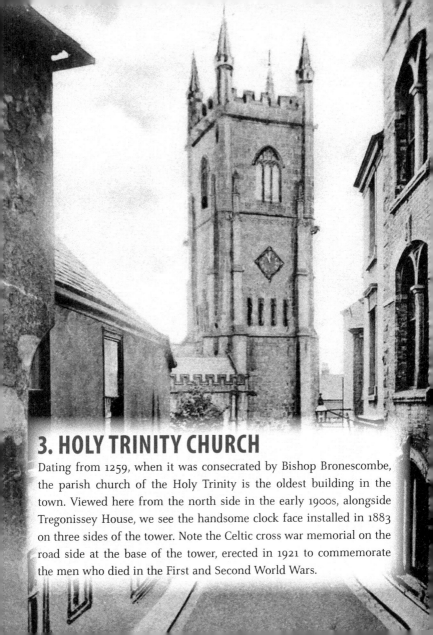

# 3. HOLY TRINITY CHURCH

Dating from 1259, when it was consecrated by Bishop Bronescombe, the parish church of the Holy Trinity is the oldest building in the town. Viewed here from the north side in the early 1900s, alongside Tregonissey House, we see the handsome clock face installed in 1883 on three sides of the tower. Note the Celtic cross war memorial on the road side at the base of the tower, erected in 1921 to commemorate the men who died in the First and Second World Wars.

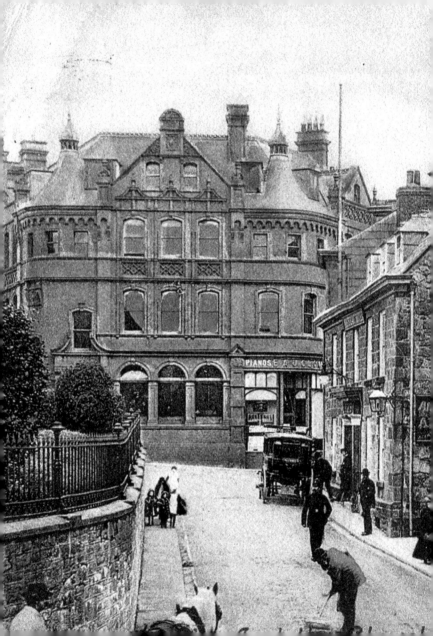

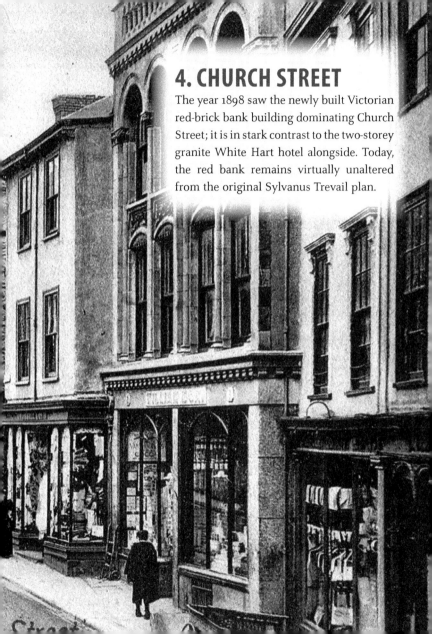

# 4. CHURCH STREET

The year 1898 saw the newly built Victorian red-brick bank building dominating Church Street; it is in stark contrast to the two-storey granite White Hart hotel alongside. Today, the red bank remains virtually unaltered from the original Sylvanus Trevail plan.

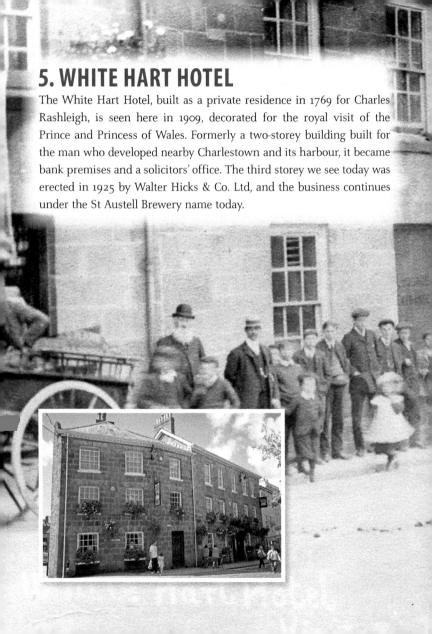

# 5. WHITE HART HOTEL

The White Hart Hotel, built as a private residence in 1769 for Charles Rashleigh, is seen here in 1909, decorated for the royal visit of the Prince and Princess of Wales. Formerly a two-storey building built for the man who developed nearby Charlestown and its harbour, it became bank premises and a solicitors' office. The third storey we see today was erected in 1925 by Walter Hicks & Co. Ltd, and the business continues under the St Austell Brewery name today.

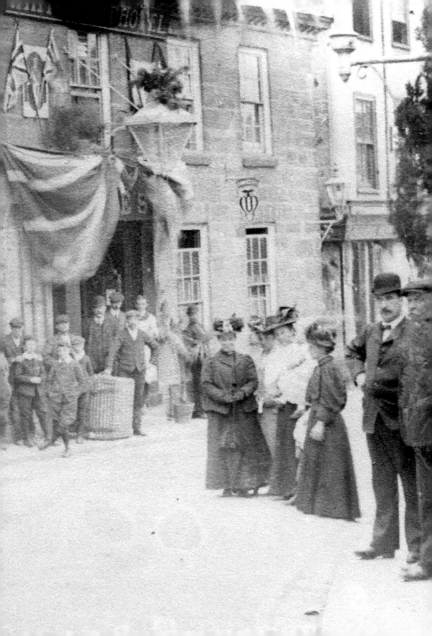

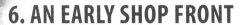

# 6. AN EARLY SHOP FRONT

One of St Austell's earliest shop fronts spanned the corner position of Church Street and Fore Street. Coats and trousers were hung outside the shop windows, while smaller items and boaters took over inside. Only the angle of the wall and the Church Street sign offer a clue to its whereabouts in 2014.

# 7. DUKE STREET

The large Congregational chapel in Duke Street was built in 1850, on the site of an even earlier chapel. In the 1880s, additions and alterations were made by Sylvanus Trevail. The chapel closed in the 1970s and was later demolished. The site formed the British Legion Garden of Remembrance and Club premises, with the new town centre behind.

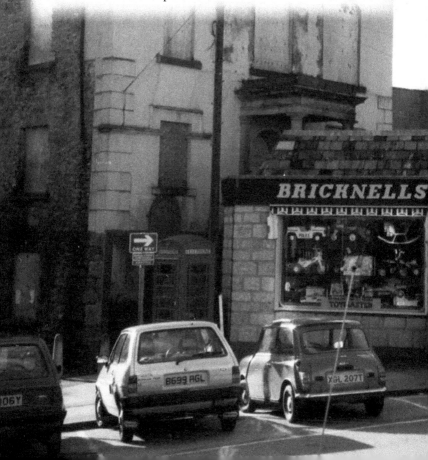

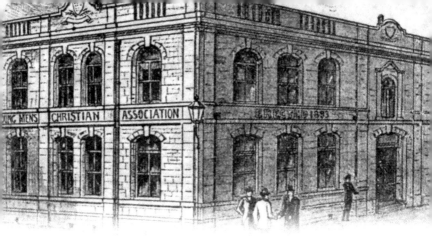

# 8. VICTORIA SQUARE

This building, erected in 1893 on the site of the Ring of Bells public house, was the first YMCA building in Cornwall. It had a gymnasium and reading room catering for the education and welfare of the young men of St Austell. The ground floor has been vastly altered over the years but the pleasant stonework, the Cornwall coat of arms and the 1893 date stone can still be seen on the ledge below the parapet.

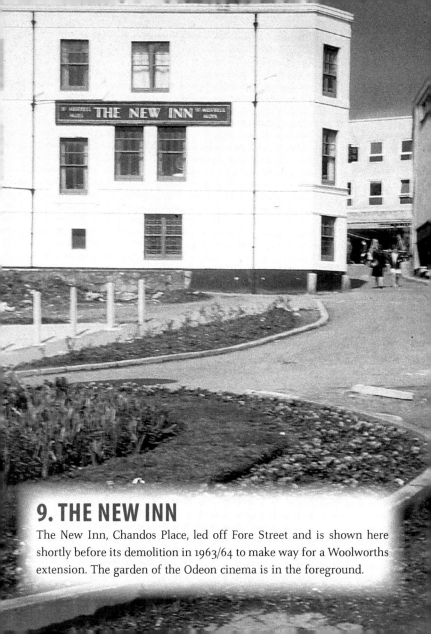

# 9. THE NEW INN

The New Inn, Chandos Place, led off Fore Street and is shown here shortly before its demolition in 1963/64 to make way for a Woolworths extension. The garden of the Odeon cinema is in the foreground.

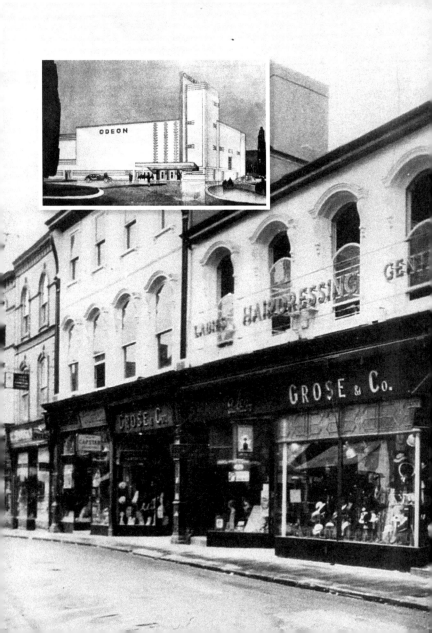

ODEON

LADIES HAIRDRESSING GENT

GROSE & Co.

GROSE & Co.

CAPSTAN

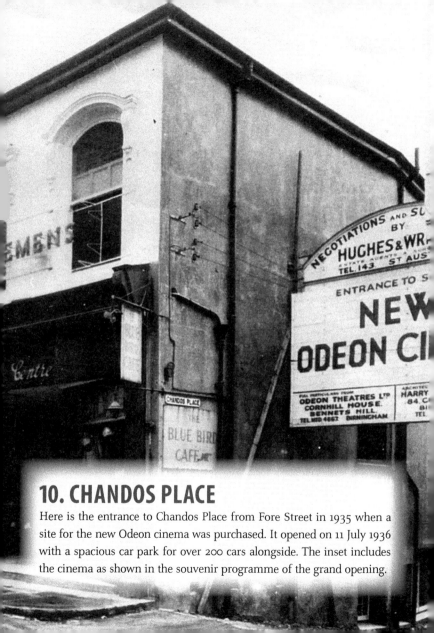

# 10. CHANDOS PLACE

Here is the entrance to Chandos Place from Fore Street in 1935 when a site for the new Odeon cinema was purchased. It opened on 11 July 1936 with a spacious car park for over 200 cars alongside. The inset includes the cinema as shown in the souvenir programme of the grand opening.

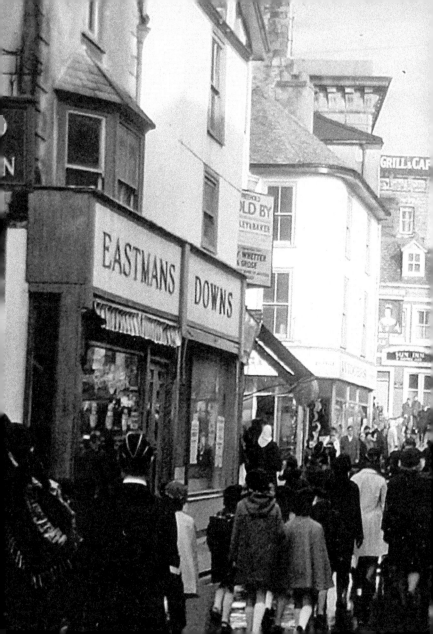

# 11. FORE STREET

An old corner of St Austell, at the end of Fore Street and directly opposite the church entrance, during the 1970 Armistice Parade. It was once the site of the Mengu stone, an ancient marker of the division of the three Domesday manors of Trenance, Tewington and Treverbyn. In 1972, it was transferred to the churchyard at the base of the tower. The old Manor House, *c.* 1700, the exterior of which is still fairly undisturbed, has a curious slated cornice halfway up.

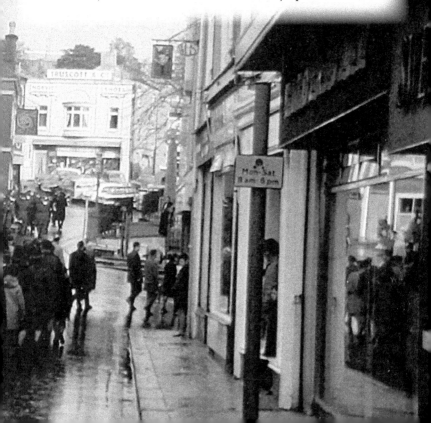

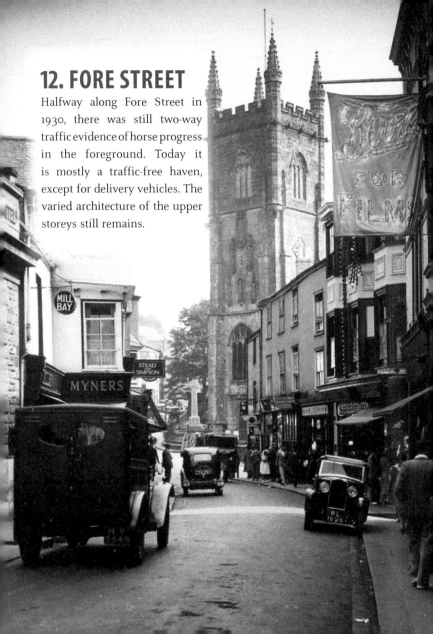

## 12. FORE STREET

Halfway along Fore Street in 1930, there was still two-way traffic evidence of horse progress in the foreground. Today it is mostly a traffic-free haven, except for delivery vehicles. The varied architecture of the upper storeys still remains.

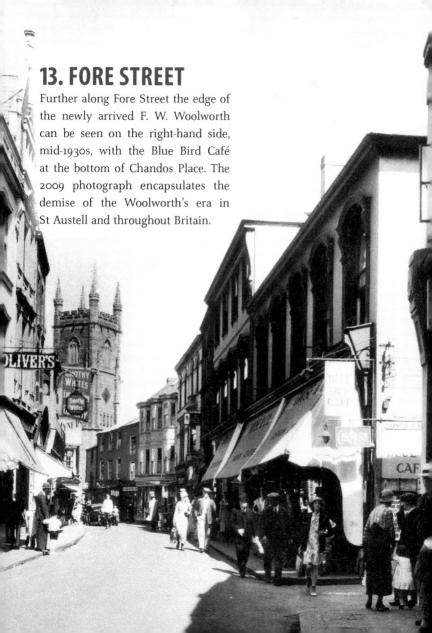

# 13. FORE STREET

Further along Fore Street the edge of the newly arrived F. W. Woolworth can be seen on the right-hand side, mid-1930s, with the Blue Bird Café at the bottom of Chandos Place. The 2009 photograph encapsulates the demise of the Woolworth's era in St Austell and throughout Britain.

# 14. NO. 37 FORE STREET

George Hawke & Son's premises, No. 37 Fore Street, in 1910. With two large display windows, it was like an Aladdin's cave. Merchandise, jammed into all available space, ranged from ladies' and gents' bicycles, iron bedsteads and paraffin lamps of every design to everyday crockery and best china. Today, the plate glass shopfronts of the usual High Street stores predominate.

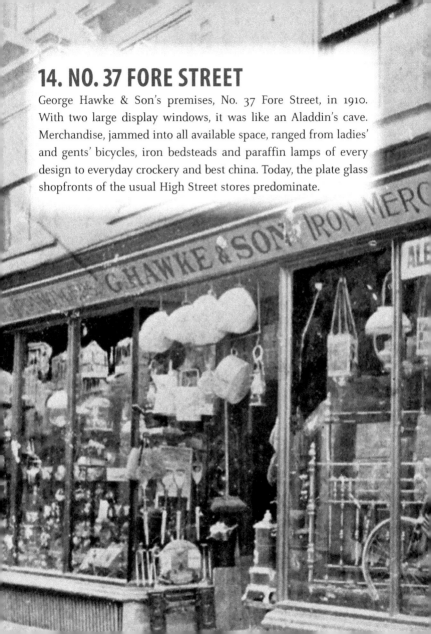

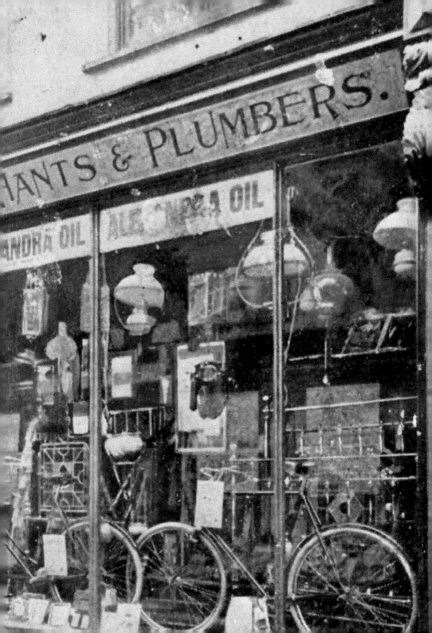

# 15. FORE STREET, WEST END

At the western end of Fore Street, where an old smithy had once stood, a Liberal Club for the town, designed by Silvanus Trevail, was built in 1890. There were around 400 members when it opened, underlying the political sympathy of the area. Although no longer the Liberal Club, the ornate front of the red and white brick and granite arched entrances are still evident today alongside much altered shop frontages.

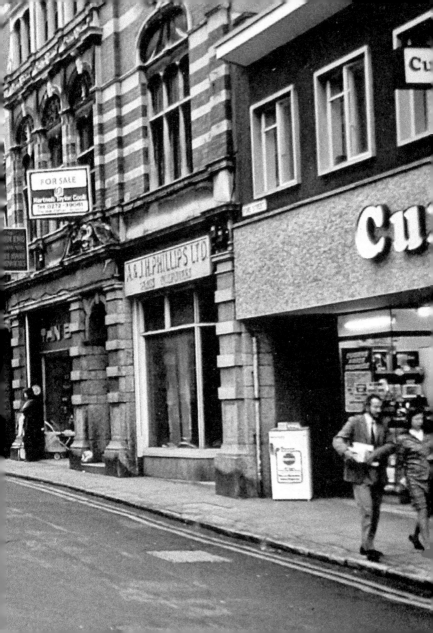

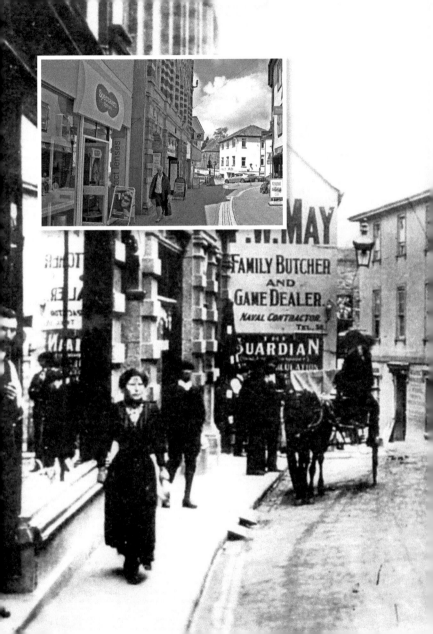

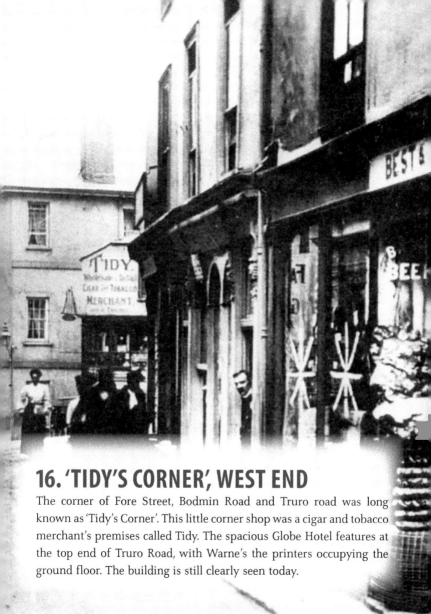

## 16. 'TIDY'S CORNER', WEST END

The corner of Fore Street, Bodmin Road and Truro road was long known as 'Tidy's Corner'. This little corner shop was a cigar and tobacco merchant's premises called Tidy. The spacious Globe Hotel features at the top end of Truro Road, with Warne's the printers occupying the ground floor. The building is still clearly seen today.

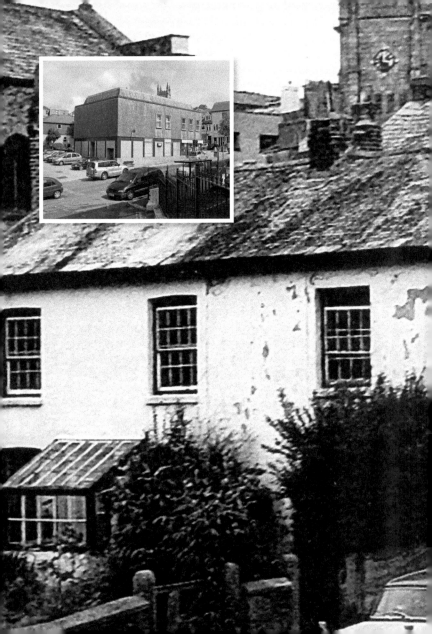

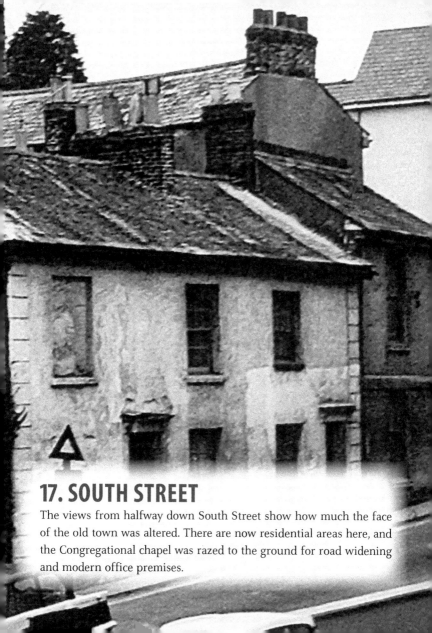

## 17. SOUTH STREET

The views from halfway down South Street show how much the face
of the old town was altered. There are now residential areas here, and
the Congregational chapel was razed to the ground for road widening
and modern office premises.

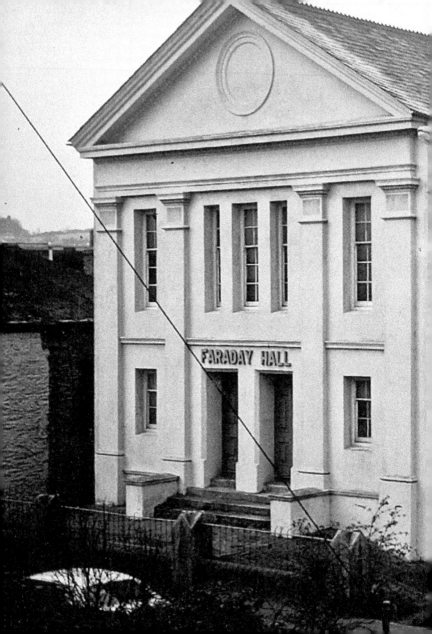

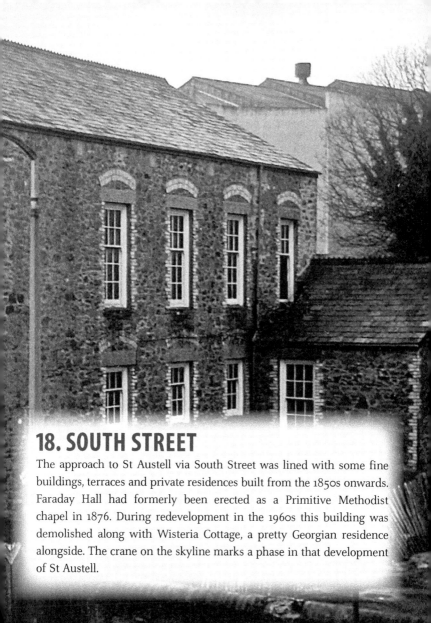

# 18. SOUTH STREET

The approach to St Austell via South Street was lined with some fine buildings, terraces and private residences built from the 1850s onwards. Faraday Hall had formerly been erected as a Primitive Methodist chapel in 1876. During redevelopment in the 1960s this building was demolished along with Wisteria Cottage, a pretty Georgian residence alongside. The crane on the skyline marks a phase in that development of St Austell.

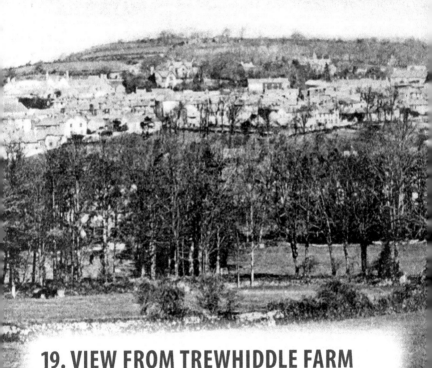

## 19. VIEW FROM TREWHIDDLE FARM

A second sweeping view from the London Apprentice side of the valley from Trewhiddle farm fields. The St Austell brewery building and flagpole can just be identified on the skyline of both images, as well as the church tower. Today, mature trees have obscured most of view.

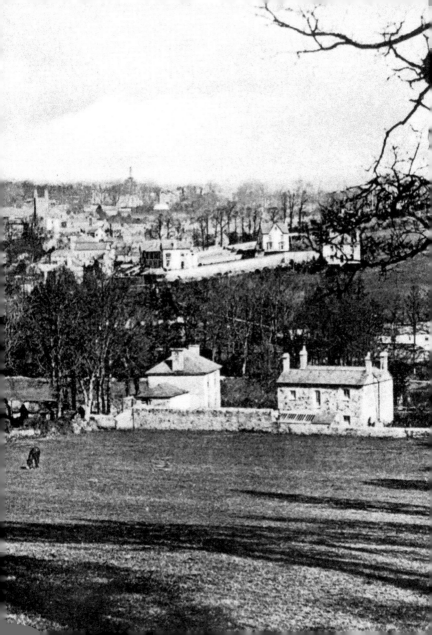

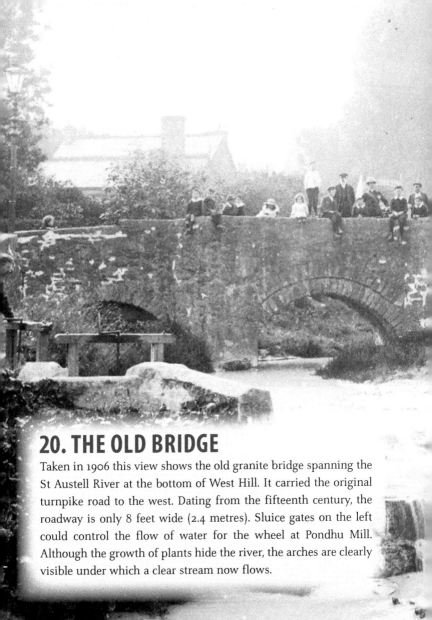

## 20. THE OLD BRIDGE

Taken in 1906 this view shows the old granite bridge spanning the St Austell River at the bottom of West Hill. It carried the original turnpike road to the west. Dating from the fifteenth century, the roadway is only 8 feet wide (2.4 metres). Sluice gates on the left could control the flow of water for the wheel at Pondhu Mill. Although the growth of plants hide the river, the arches are clearly visible under which a clear stream now flows.

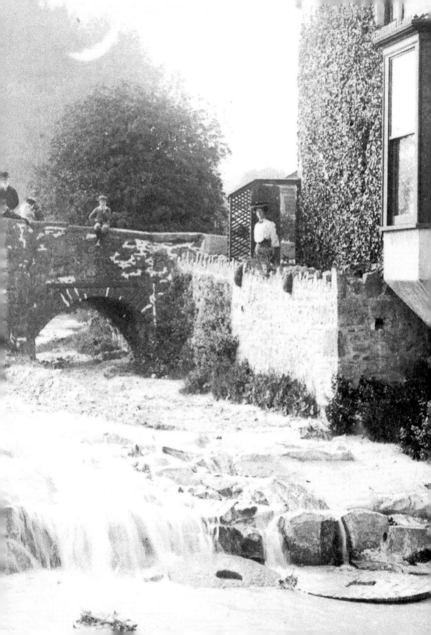

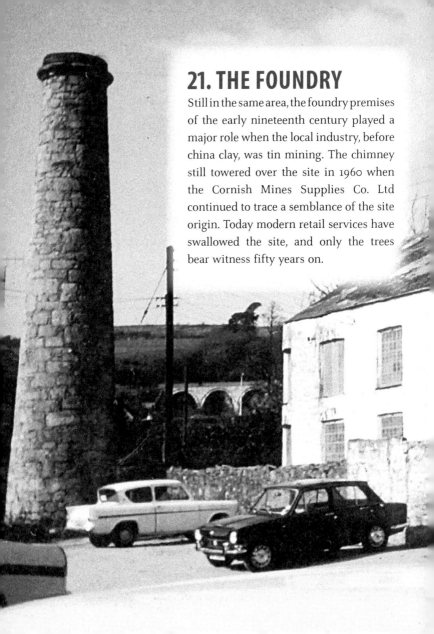

## 21. THE FOUNDRY

Still in the same area, the foundry premises of the early nineteenth century played a major role when the local industry, before china clay, was tin mining. The chimney still towered over the site in 1960 when the Cornish Mines Supplies Co. Ltd continued to trace a semblance of the site origin. Today modern retail services have swallowed the site, and only the trees bear witness fifty years on.

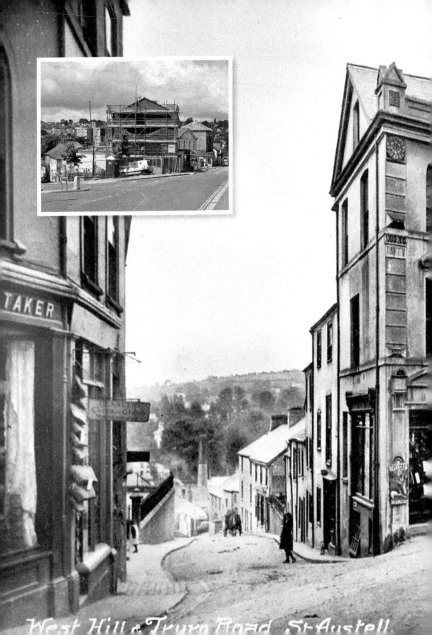

West Hill & Truro Road, St Austell

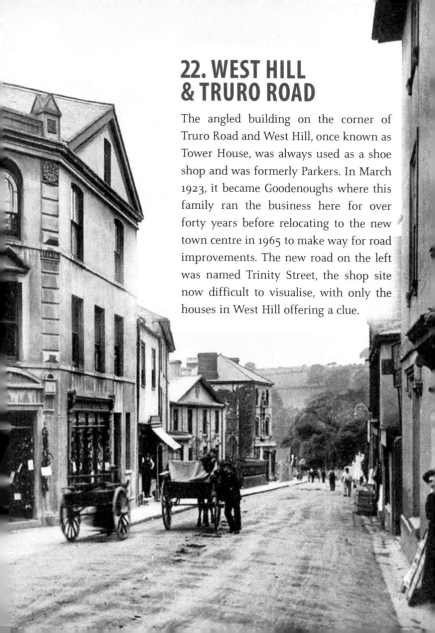

## 22. WEST HILL & TRURO ROAD

The angled building on the corner of Truro Road and West Hill, once known as Tower House, was always used as a shoe shop and was formerly Parkers. In March 1923, it became Goodenoughs where this family ran the business here for over forty years before relocating to the new town centre in 1965 to make way for road improvements. The new road on the left was named Trinity Street, the shop site now difficult to visualise, with only the houses in West Hill offering a clue.

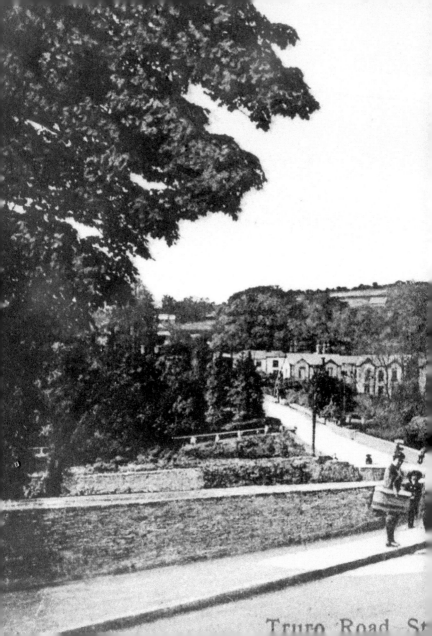

Truro Road. St

# 23. TRURO ROAD

Truro Road was built in 1834. This gently wooded approach to St Austell stressed the newly acquired wealth brought to the town by the china clay industry, and substantial new dwellings were built by the clay magnates. A new bridge was constructed over the St Austell River. Some of the fine specimens of the trees remain in the grounds of the Trevarrick residences.

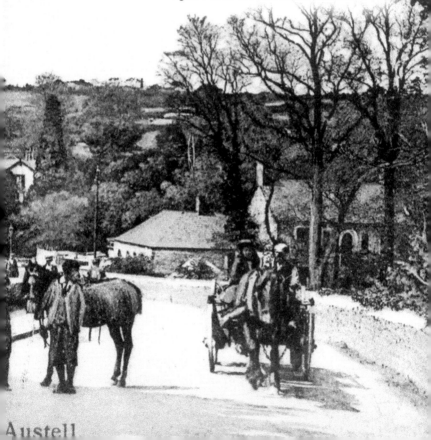

Austell

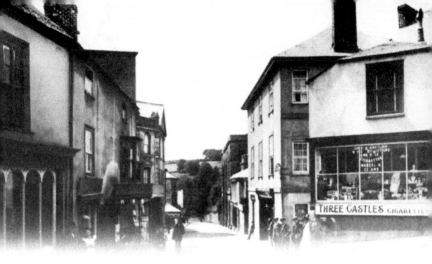

## 24. TRURO ROAD

A closer look at the junction of Truro Road into Fore Street. The Globe Hotel and the imposing building of the Public Rooms on the right, further down on both views. Old shop frontages on the left hide the approach to the West Hill exit to the town. Open fields in the distance are now occupied by houses at Trevarrick.

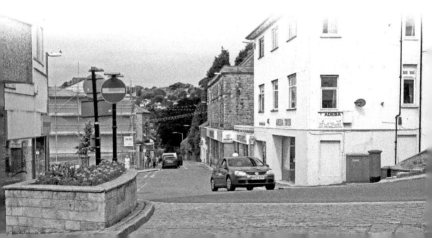

# 25. MONUMENTAL MASONS

Doney, Son, Watts & Trevail premises in Truro Road was an ornate building and a showroom known as statuary masons. Note the fine statue on the plinth outside on the pavement and glass-domed alabaster-carved grave wreaths in the shop display. The building structure remains intact, the alcove above the main entrance still clearly definable, minus the figure.

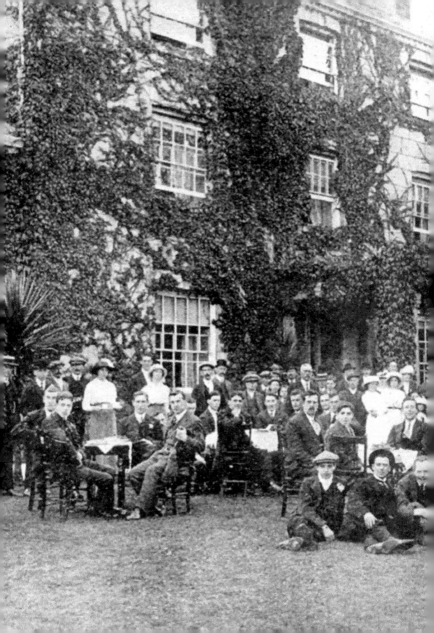

# 26. TREVARRICK HALL

Trevarrick, a former estate in the western area of Trenance, was owned by Henry Hodge Esq. in 1914. The old view shows recruits for the Cornwall Light Infantry being entertained on the lawns in front of the house. The fine ashlar stonework and porch is still in evidence today, even more accentuated by the removal of the ivy or Virginia creeper of yesteryear.

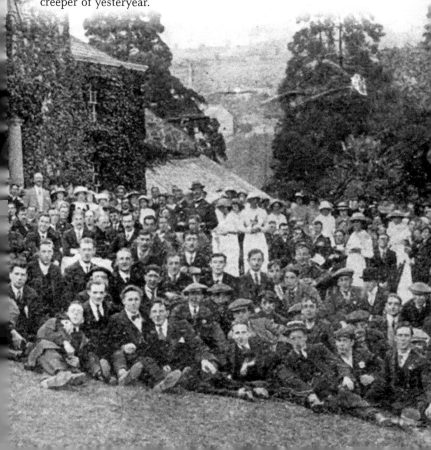

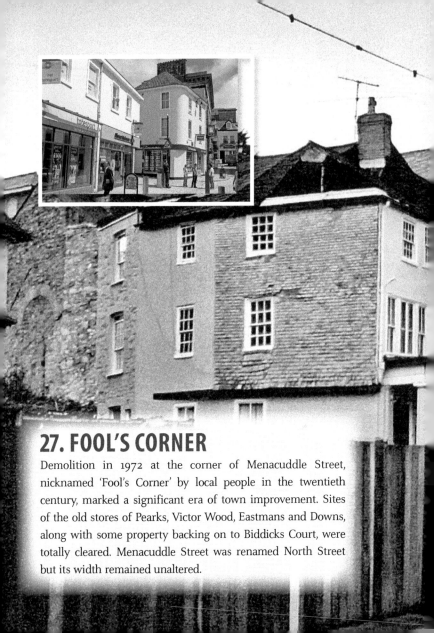

## 27. FOOL'S CORNER

Demolition in 1972 at the corner of Menacuddle Street, nicknamed 'Fool's Corner' by local people in the twentieth century, marked a significant era of town improvement. Sites of the old stores of Pearks, Victor Wood, Eastmans and Downs, along with some property backing on to Biddicks Court, were totally cleared. Menacuddle Street was renamed North Street but its width remained unaltered.

# 28. MENACUDDLE STREET

An old corner of St Austell, at the end of Fore Street and directly opposite the church entrance. It was once the site of the Mengu stone, an ancient marker of the division of the three Domesday manors of Trenance, Tewington and Treverbyn. In 1972, it was transferred to the churchyard at the base of the tower. The old Manor House, *c.* 1700, has a curious slated cornice halfway up.

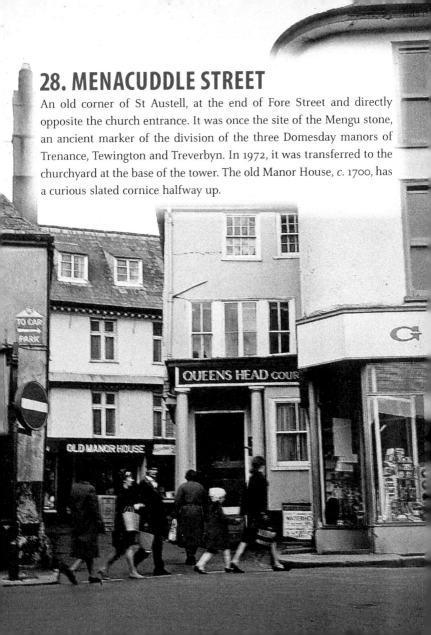

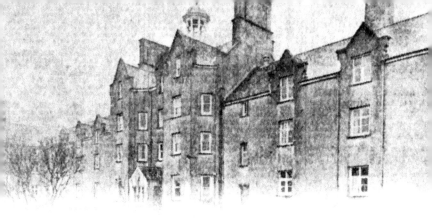

# 29. SEDGEMOOR PRIORY

This old cutting shows the workhouse built in 1839 for the parish. It replaced a former one at the bottom of West Hill on a site known as Workhouse Lane. The new building was erected in part of the old Sedgemoor Priory grounds and could take 300 inmates. In 1954 it was a home for old and infirm people. Today the new offices, known as Sedgemoor Centre, are managed by Cornwall Council Adult Care Support, so, interestingly, the site is still caring for the community.

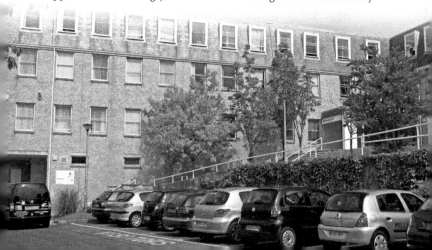

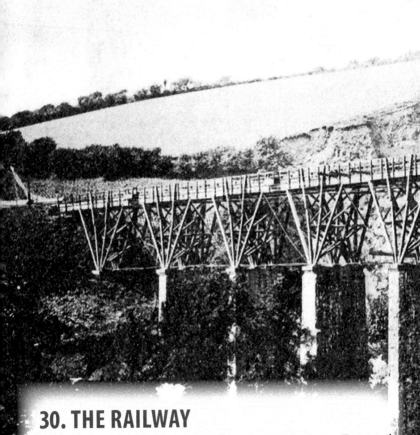

## 30. THE RAILWAY

The railway came through St Austell in 1859 continuing to Truro and the West. This old view of the first trestle bridge, carrying the single track, which was erected by Isambard Kingdom Brunel, shows the inverted wooden trestles fixed to stone piers. The remains of these pillars are still visible today alongside the new granite viaduct for the double track.

AN OLD CORNISH RAILWAY VIADUCT
TRENANCE NEAR ST AUSTELL

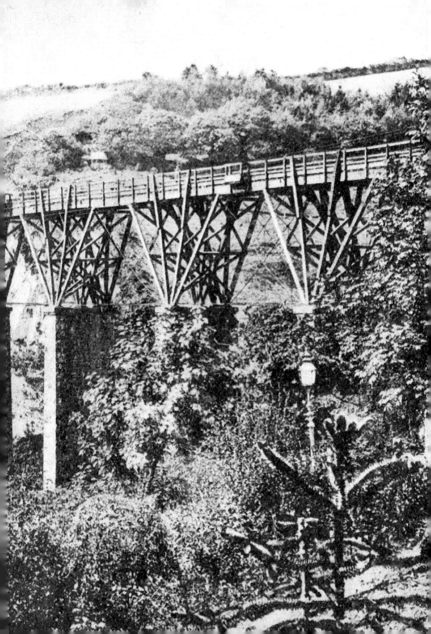

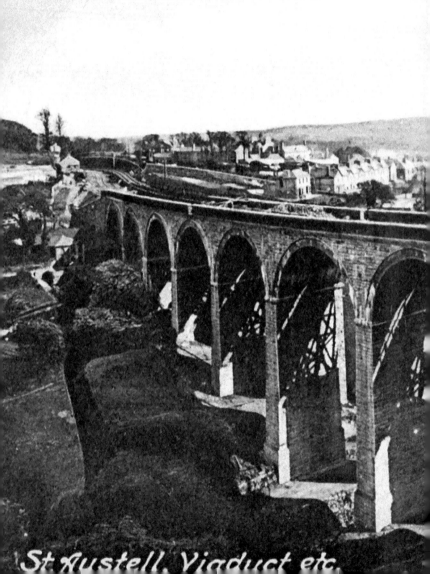

St Austell, Viaduct etc.

# 31. THE VIADUCT

In 1898 a replacement viaduct was built of local granite to carry a double track. Ten brick arches spanned the valley overlooking Trenance Mill and the industrial area around. On the left, at the beginning of the viaduct nearest the town, the toll house, built in 1840, is just visible on the Bodmin Road.

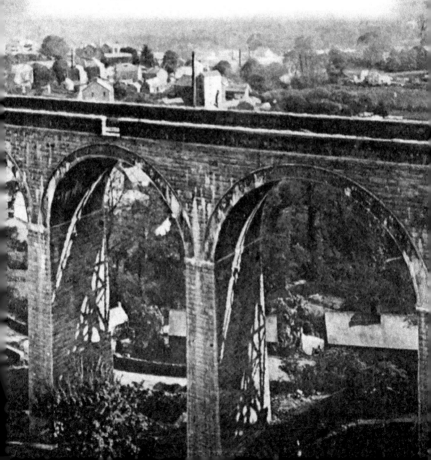

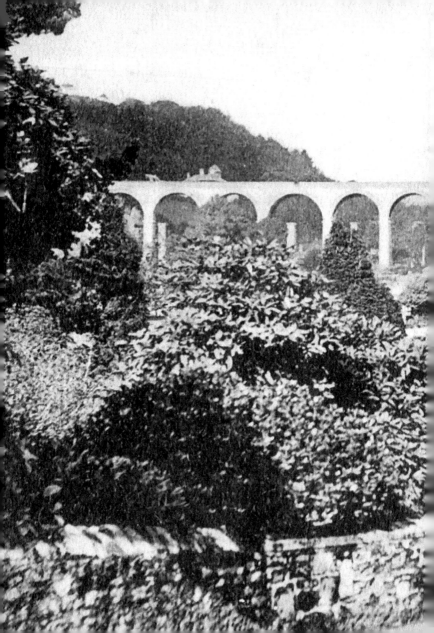

# 32. TRENANCE

Standing in Truro Road opposite the park it is still possible to see the granite viaduct, built to take the trains onward from St Austell through Cornwall, spanning the Trenance Valley.

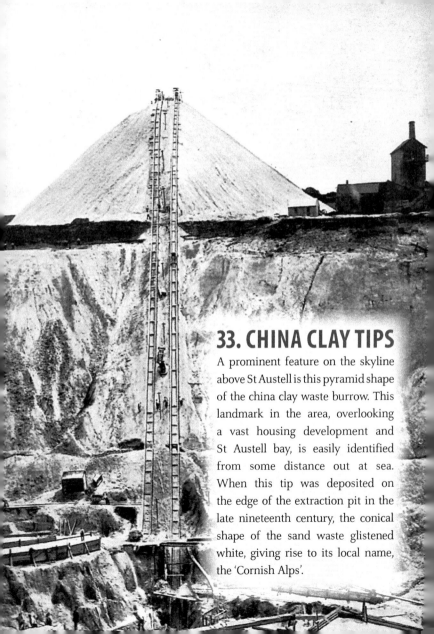

## 33. CHINA CLAY TIPS

A prominent feature on the skyline above St Austell is this pyramid shape of the china clay waste burrow. This landmark in the area, overlooking a vast housing development and St Austell bay, is easily identified from some distance out at sea. When this tip was deposited on the edge of the extraction pit in the late nineteenth century, the conical shape of the sand waste glistened white, giving rise to its local name, the 'Cornish Alps'.

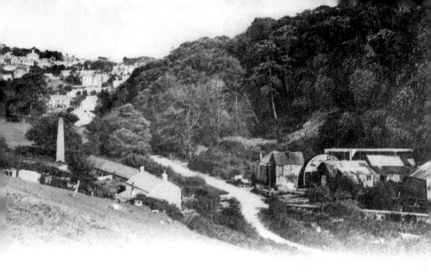

## 34. GOVER MILL

Still an industrial scene in 1920, Gover mill in the Trenance valley shows a rural aspect, with the town beyond. The huge overshot waterwheel, fed by a long wooden launder, and a cluster of mill houses on the banks of the river all contribute to the industrial past. St Austell, seen in the background, has finally encroached upon this site with new residential building.

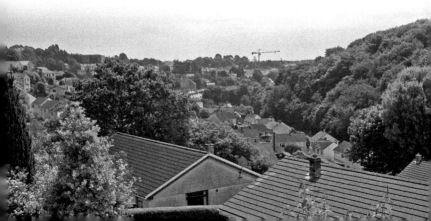

# 35. PALACE ROAD

Palace Road was newly built and developed after the advent of the Great Western Railway from Plymouth into Cornwall in 1859. Several new residences were built by the clay magnates or prosperous business people in the town, set back off the road within their own spacious grounds. The walls remain today, but the fine gas lamps and seats have disappeared.

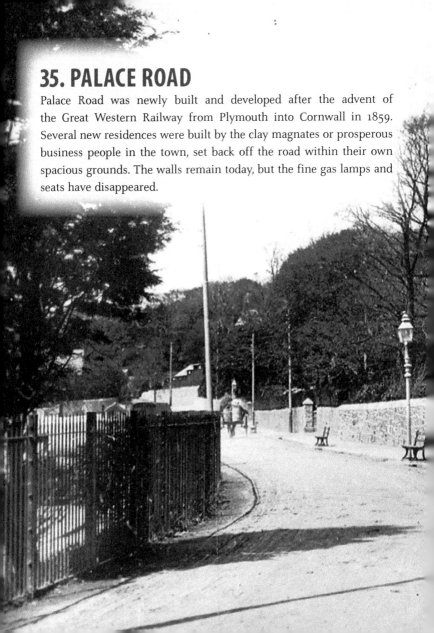

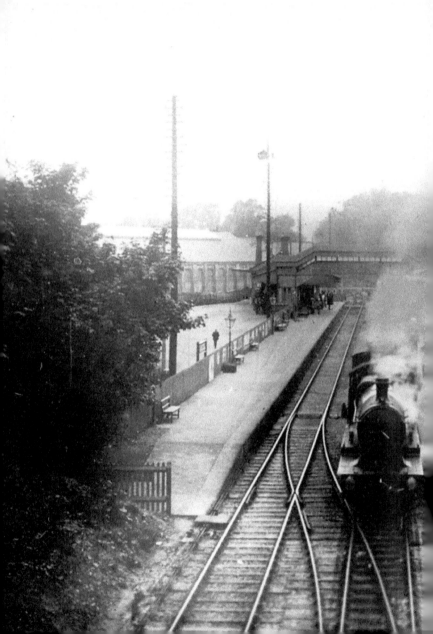

# 36. RAILWAY STATION

St Austell station, *c.* 1912, with the upward line train, the engine getting up steam to depart and the water tower nearby. On the left by the station buildings was a large goods siding and on the right other goods wagons have been shunted back into more sidings below Palace Road. The main goods depot was transferred to yards at Polkyth in 1931. Cars now park in that area to the right. Note the GWR dated footbridge, which is still evident today.

# 37. STATION PREMISES

A few goods trains still used the sidings below Palace Road in the 1950s but the Western National bus company has also entered the scene, providing services to all the outlying district and villages. Cattle pens are still in situ on the siding to the left of bus No. 68. Today, access to the yard is completely overgrown.

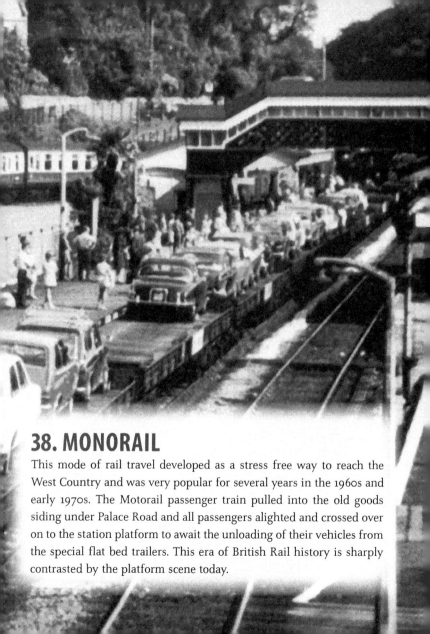

## 38. MONORAIL

This mode of rail travel developed as a stress free way to reach the West Country and was very popular for several years in the 1960s and early 1970s. The Motorail passenger train pulled into the old goods siding under Palace Road and all passengers alighted and crossed over on to the station platform to await the unloading of their vehicles from the special flat bed trailers. This era of British Rail history is sharply contrasted by the platform scene today.

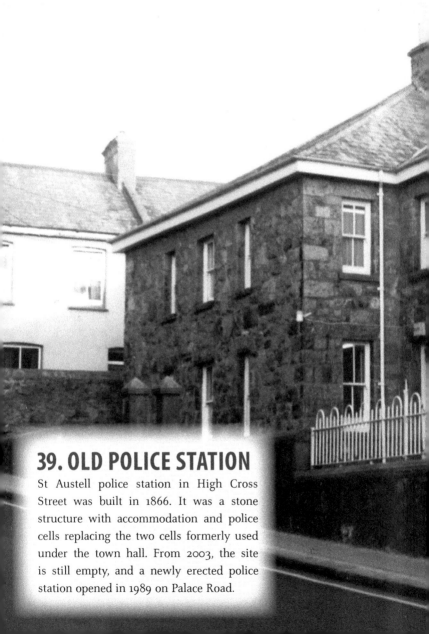

# 39. OLD POLICE STATION

St Austell police station in High Cross Street was built in 1866. It was a stone structure with accommodation and police cells replacing the two cells formerly used under the town hall. From 2003, the site is still empty, and a newly erected police station opened in 1989 on Palace Road.

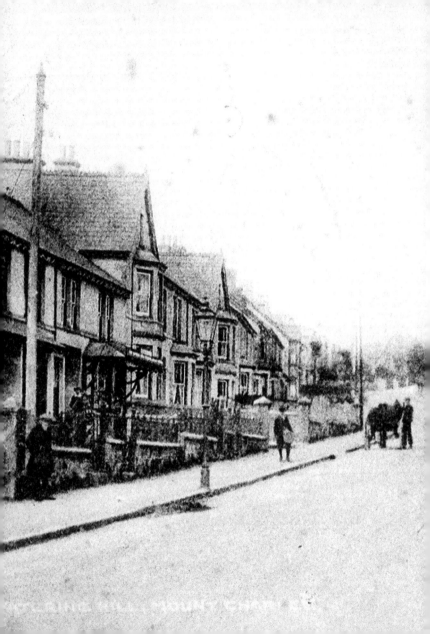

HOLDING HILL, MOUNT CHARLES

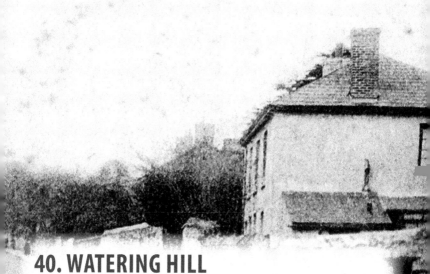

## 40. WATERING HILL

An approach to St Austell from the easterly direction *c.* 1910. The old name of Watering Hill evolved from the days of horse-drawn traffic when horses would stop for watering from the open river at the bottom of the hill. It was renamed Alexandra Road sometime after the accession of Edward VII and Queen Alexandra, who was beloved by her subjects. The shop canopy on the left was a small grocery store for many years for Messrs Turner, Higman & Jacob and is still visible today as a much-enlarged electrical home appliance store.

# 41. JENKINS GARAGE

This garage site was let to J. Jenkin on a twenty-one-year lease from 1910. At the base of Alexandra Road, it was ideally situated on the main traffic route in and out of the town. It was sold by public auction in 1922, but no further building evolved and today it is a car park for Capitol bingo and other businesses nearby.

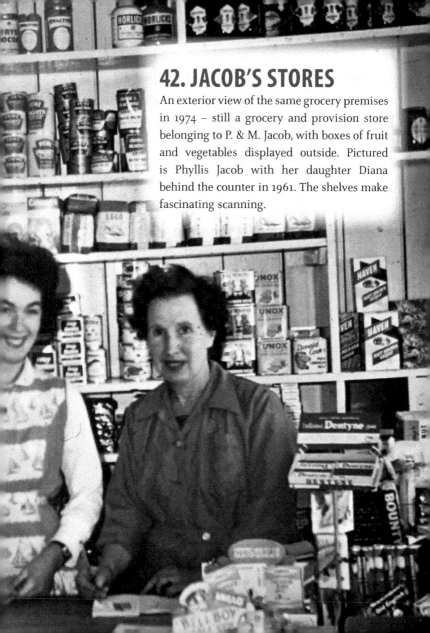

## 42. JACOB'S STORES

An exterior view of the same grocery premises in 1974 – still a grocery and provision store belonging to P. & M. Jacob, with boxes of fruit and vegetables displayed outside. Pictured is Phyllis Jacob with her daughter Diana behind the counter in 1961. The shelves make fascinating scanning.

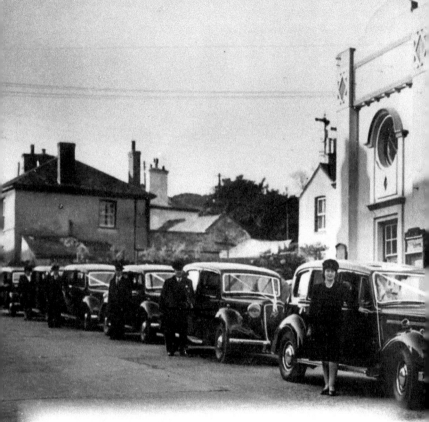

## 43. CAPITOL CINEMA

At the bottom of Alexandra Road the second cinema was built for
St Austell. It had a ballroom and restaurant as well as an auditorium
for the screening of the films. The line of wedding cars in 1948 were
waiting for the guests and bridal party after the reception in the
ballroom upstairs. The Rolls Royce with the owner alongside headed
the line. Today the modern building houses Capitol bingo sessions.

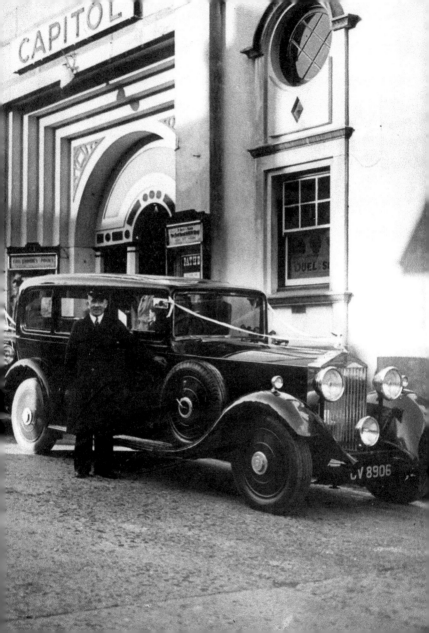

## 44. MOORLEIGH

This large residence called Moorleigh, on Victoria Road, was built by Mr Thomas Treleaven, *c.* 1888. He was a prominent businessman of the town and had corn merchant premises in East Hill. Surrounding grounds hid the house from general view and the extensive gardens, green houses, coach house and yard stretched into Wesley Place at the rear. The house was sold in the 1960s and an estate of town houses was built on the site. The only clue to its former history is the retained name Morleigh Close on the left of the roadside wall.

## 45. VICTORIA ROAD

Victoria Road led into Mount Charles, once the next village settlement after St Austell. The view shows a very empty thoroughfare at the turn of the twentieth century. The horse-drawn vehicle loaded with wooden clay casks can travel safely in the middle of the road.

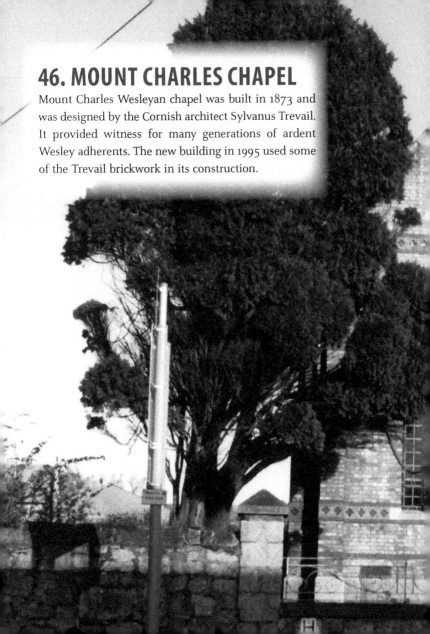

# 46. MOUNT CHARLES CHAPEL

Mount Charles Wesleyan chapel was built in 1873 and was designed by the Cornish architect Sylvanus Trevail. It provided witness for many generations of ardent Wesley adherents. The new building in 1995 used some of the Trevail brickwork in its construction.

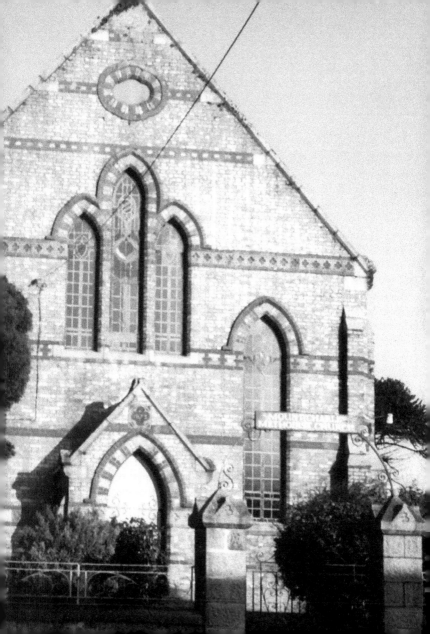

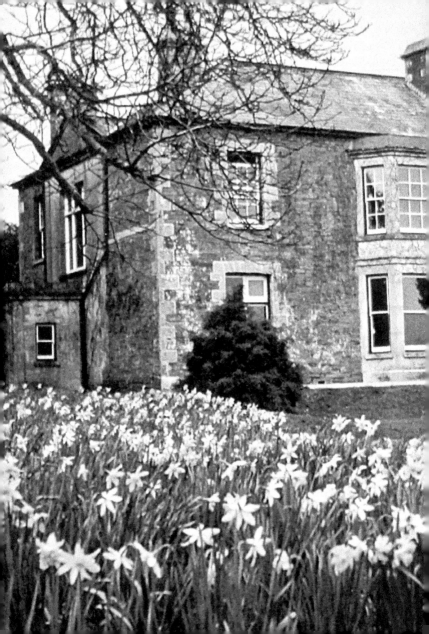

# 47. POLKYTH HOUSE

This fine house was built on the outskirts of the town in Carlyon Road and was the substantial home of J. S. Lovering. Only the name in the leisure centre complex remains after 1974 plus a few fine trees which had been planted in the grounds of Polkyth by the Lovering owners.

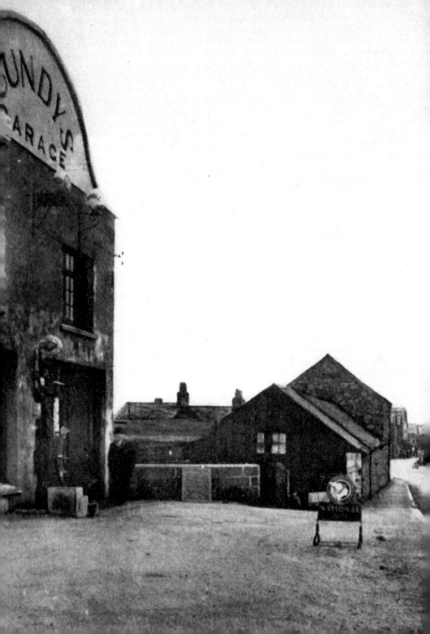

# 48. TRELEAVEN'S CROSS

Carlyon Road leads on to the crossroads at Treleaven's Cross, where Slades and Clifden Roads and Sandy Hill all meet. The barns and farm outbuildings of Mr Jenkins and Cundy's garage on the left were a landmark feature in the area for many years. Today only the large building in the centre is identifiable. Formerly a well-stocked shop owned by Mr Bohemia – a newsagent, clothes store and fancy goods outlet – the corner took the name Bohemia's from its owner. A new supermarket is on the garage site.

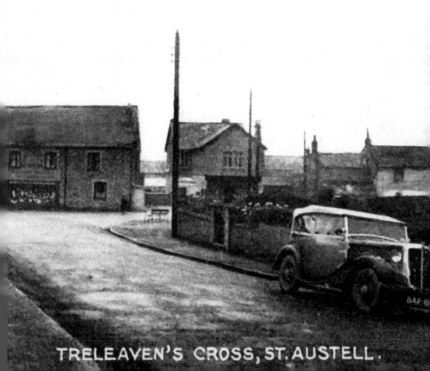

TRELEAVEN'S CROSS, ST. AUSTELL.

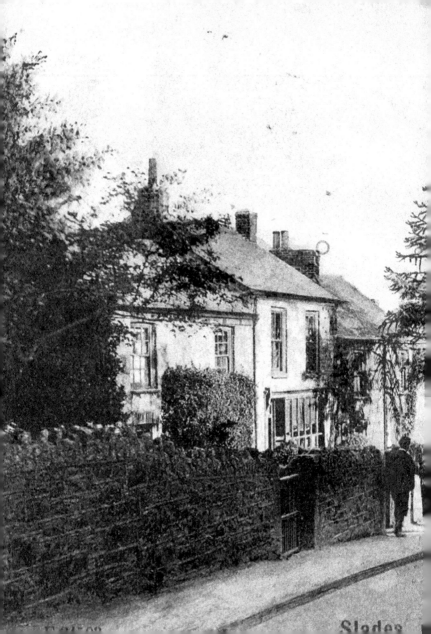

Slades

## 49. SLADES

From the crossroads at Mount Charles the road through Slades led to Bugle and Bodmin. The view before the buildings on the right showed the tree-lined gardens at the beginning of the twentieth century in 1907. On the left, halfway down the scene, is the shop premises of Warricks. Today this building is still a shop, with an advertisement displayed on the gable end.

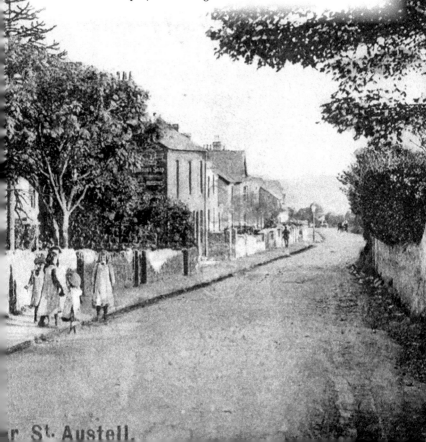

r St. Austell.

# 50. SANDY HILL

The view down Sandy Hill from Treleaven's Cross shows rough hedges and no development leading past the farm on the left. It is traffic free and seems a quiet backwater leading on to the village of Bethel. Today, all the hedges have gone and a large primary school has been built on the left-hand side.

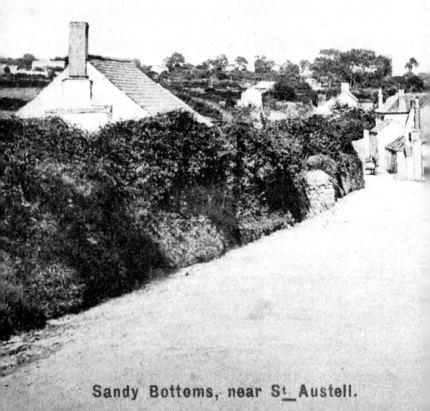

Sandy Bottoms, near St. Austell.

E 34515

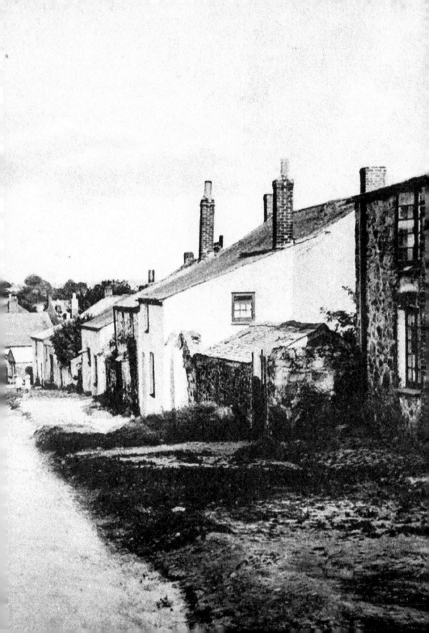

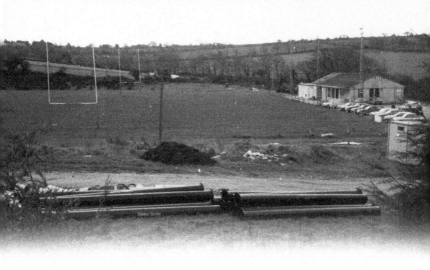

# 51. THE BYPASS

The St Austell bypass has seen many changes since its opening in 1926. The local rugby club played in this field on Cromwell Road sharing its site with the travelling circus when it came to St Austell in the 1950s and 1960s. The elephants walked in single file from the railway station to the field. In 1988 the land was acquired by Asda, a dramatic change of use.

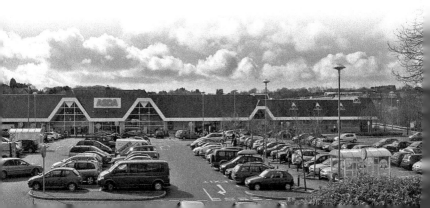

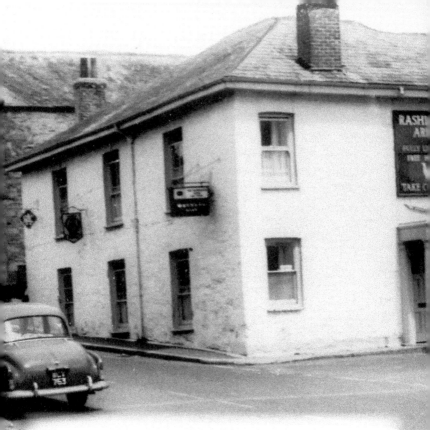

## 52. AROUND THE COAST

Charlestown, the nearest port and harbour to St Austell, developed
from a small fishing village in the eighteenth century to cope with the
expanding china clay trade. Early buildings included the Methodist
chapel in 1827 and the first hotel, later named the Rashleigh Arms
in deference to Charles Rashleigh of Duporth, who engineered the
building of the fine harbour and inner basin. The same porch is still
in use today as entrance to the Rashleigh Arms.

# 53. CHARLESTOWN HARBOUR

Both views show the inner basin at Charlestown closed by the metal gates, with bridge over, to contain the water for the vessels within. The older view with the chutes for loading china clay can be seen on the left-hand dock wall. Today, very old sailing vessels can be seen, but they are owned by Square Sails for the tourist trade.

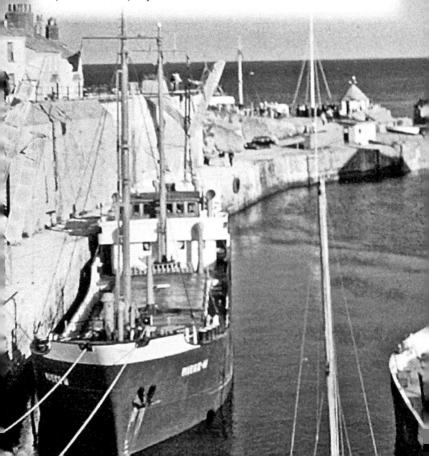